Charleston, OU

It's old with lots of new!
It's safe

but sometimes spooky!

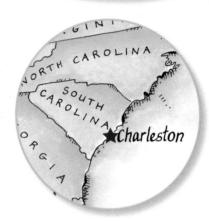

he places where you live and visit help shape who you become. So find out all you can about the special places around you!

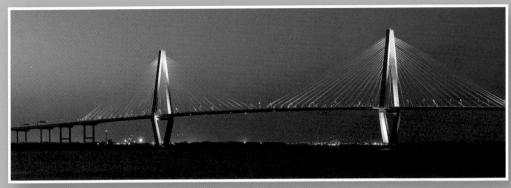

Night view of the Arthur Ravenel Jr. cable-stayed bridge in Charleston, SC

CREDITS

Series Concept and Development

Kate Boehm Jerome

Series Design

Steve Curtis Design, Inc. (www.SCDchicago.com)

Reviewers and Contributors

Stacey L. Klaman, writer and editor, San Diego, CA Marc Rapport, Manager Media Relations, SC Department of Parks, Recreation & Tourism

Special thanks to Mayor Joseph P. Riley Jr.

Photography

Cover(a), Back Cover(a), i(a) © Lawrence Cruciana/Shutterstock; Cover(b), Back Cover(b), i(b) © Katherine Welles/Shutterstock; Cover(c) © iofoto/Shutterstock; Cover(d), ix(b), x, xii(a), xvi(c) © Perry Baker/SCPRT; Cover(e), v, xvi(a) © Russ Pace/The Citadel; Cover(f) © Dariush M./Shutterstock; iv(ii), xvi(b) © Shutterstock; ii, vi(a), ix(c), xi(b), xvi(e) © Jason Tench/Shutterstock; iv-v © Filipe B. Varela/Shutterstock; iv © Brownie Harris/City of Charleston; © vi(b) J. Norman Reid/Shutterstock; vi(a) © J. Norman Reid/Shutterstock; viii(b) © Torian/Shutterstock; viii(a) © David Davis/Shutterstock; viii(b) © K. Chelette/Shutterstock; viii(c) © Sebastien Windal/Shutterstock; xi(a) © John Wollwerth/Shutterstock; xi(a) © stocksnapp/Shutterstock; xiii(b) © A. Paterson/Shutterstock; xiii(a) © Beth Whitcomb/Shutterstock; xiii(b) © Michael Rickard/Shutterstock; xiv-v © Joe Ginsberg/Stockbyte/Getty Images; xi(v) © NOAA; xv(a) © Sparky Witte; xv(b) © Condor 36/Shutterstock; xvi(c) © J. K. Hillers/USGS; xvi(d) © Lisa F. Young/Shutterstock; xvi(f) © modellocate/Shutterstock; xvi(g) © John Wollwerth/Shutterstock; xvi(h) © Brad Sauter / Shutterstock. See Slate Section Credits (1-31) on page 32

Illustration

i © Jennifer Thermes/Photodisc/Getty Images

Copyright © 2008 Kate Boehm Jerome. All rights reserved. No part of this book may be used or reproduced in any manner without written permission except in the case of brief quotations embodied in critical articles and reviews.

ISBN 978-1-4396-0001-6

Library of Congress Catalog Card Number: 2008937171

Published by Arcadia Publishing

Charleston SC, Chicago IL, Portsmouth NH, San Francisco CA

For all general information contact Arcadia Publishing at:

Telephone 843-853-2070

Fax 843-853-0044
Email sales@arcadiapublishing.com
For Customer Service and Orders:
Toll-Free 1-888-313-2665

Visit us on the Internet at www.arcadiapublishing.com

Contents

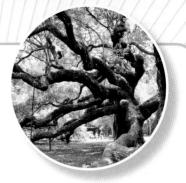

Charleston

Meet the Expert!i	i۷
By the Numbers	۷i
Sights and Soundsvi	iii
Strange But True	.X
Marvelous Monikersx	ίij
Dramatic Daysxi	i۷
South Carolina	
What's So Great About This State	1
The Land	2
Gorges	4
Beaches and Barrier Islands	6
Lakes and Rivers	8
The History1	0
Monuments 1	2
Museums 1	4
Plantations 1	6
The People1	8
Protecting2	02
Creating Jobs2	2
Celebrating2	4
Birds and Words	26
More Fun Facts	
Find Out More3	80
South Carolina: At a Glance	

IMESI STATE

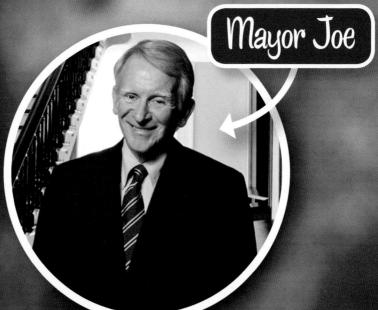

Charleston is a pretty interesting city. How do we know? Because Mayor Joe Riley told us—and he's been the mayor of Charleston for more years than you've been alive! He was first elected mayor of the city in December 1975.

By 1690, Charleston (or Charles Town!) was the fifth largest city in America. At the time of the Revolutionary War, Charleston was the fourth largest city in America.

What would you stand in line for in Charleston?

I would stand in line to go to the South Carolina Aquarium. It tells such a wonderful story about our area.

Why do you love being Mayor so much?

I love my job. I can't wait to get to work every day and do the very best job I can in helping Charleston become a more beautiful and more wonderful place to live in and to visit—for people of all ages.

M ayor Riley even has a baseball park named after him—Mayor Joe Riley Jr. Park, otherwise know as **The Joe!**

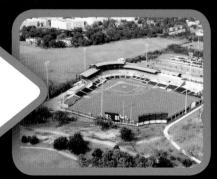

By The Numbers

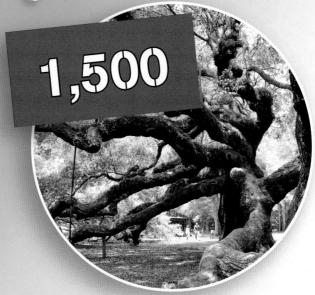

Some people estimate that the Angel Oak tree on Johns Island has been growing for almost 1,500 years. Although the tree's exact age cannot be determined, it's the city of Charleston's job to take care of this beautiful old oak.

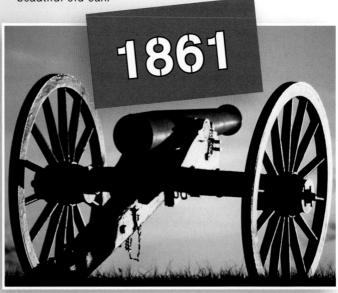

In that year, the first shots of the Civil War rang out over Charleston's Harbor.

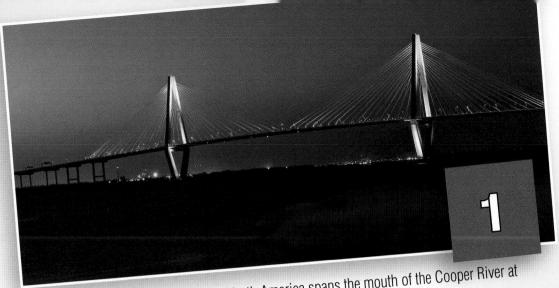

The longest cable-stayed bridge in North America spans the mouth of the Cooper River at Charleston Harbor.

4,000,000

Approximately four million tourists visit the Charleston area each year.

More Numbers!

The number of passengers traveling out of Charleston in 1830 on the first scheduled steam locomotive trip.

The average number of days of sunshine that Charleston enjoys each year.

The number of large hills or mountains in Charleston.

Sights Sound Sound

Hear

...the bells of St. Michael's ringing. The church was opened in 1761—and the bells are still rung by hand! President George Washington was one famous visitor to worship at this church.

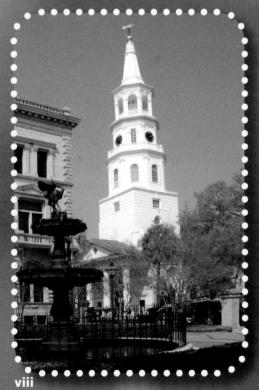

Smell

...the fresh-baked praline candy. It's made every day and sold in candy shops around the city.

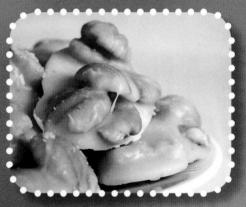

...the salt in the air from the ocean water in Charleston's harbor.

See

...the sweetgrass baskets being made and sold on Market Street.

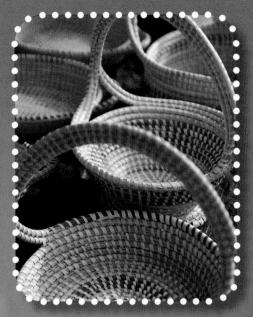

...the old cannons and eak trees in White Point Garden—commonly known as Battery Park. In the early 18th century, the park was a public hanging place where Stede Bonnet (a real pirate) and others met their end!

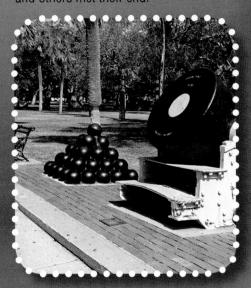

Explore

...at Charles Towne Landing! This historic site shows you what it was like to be one of the original settlers of the city.

...the fountains at Waterfront Park! The pineapple fountain is a symbol of welcome to all.

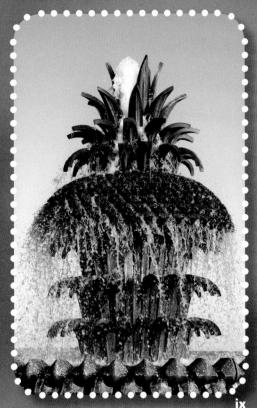

SUPPLIE

STEEPLE STOP!

Folklore says that no building in Charleston can be built higher than the tallest church steeple. Although the allowable height for new construction actually varies throughout the city, most buildings in Charleston are no more than 12 stories high.

GHOST WALKS

One of the most popular tours of the city takes people to places where ghosts are supposed to appear. Since the city is more than three hundred years old, there are lots of long-ago residents with many interesting stories. Are there really ghosts in Charleston? You be the judge!

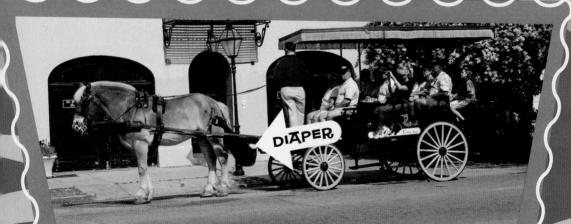

DIAPER DUTY

Horse-drawn carriages offer popular tourist rides through downtown Charleston. But every horse that pulls a carriage wears a diaper. This cuts down on cleanup and keeps the streets of Charleston as odor-free as possible.

Charleston:

arvelous onikers

What's a moniker? It's another word for a name...and Charleston has plenty of interesting monikers around town!

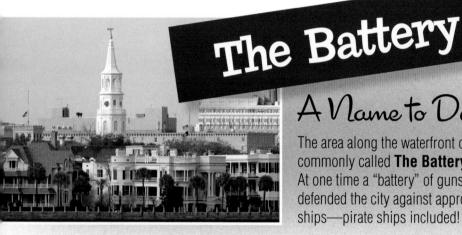

A Name to Defend

The area along the waterfront of the city is commonly called The Battery. Why? At one time a "battery" of guns and cannons defended the city against approaching enemy ships—pirate ships included!

Tasty Names

Hoppin' John—a dish made with rice and peas often seasoned with pork, onions, and peppers. She Crab Soup—a rich soup made with blue crab meat and roe (eggs).

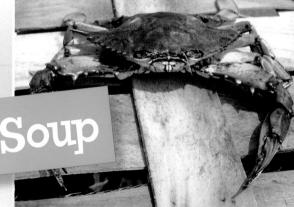

She Crab Sou

Two Meeting Street Inn

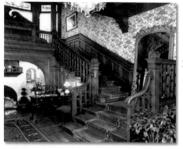

Located in the heart of the historic district, the Inn is remarkably private and quiet yet only minutes away from Charleston's restaurants and shopping areas.

Featured in Southern Living Magazine, the Inn has nine elegantly adorned guest bedrooms with private baths and queen size beds.

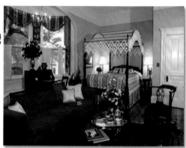

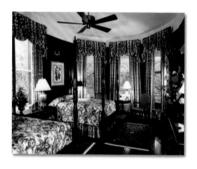

Enjoy intimate surroundings by the fire in the parlor, outside on the porch or in the garden courtyard under the ancient live oak tree.

The Tiffany stained glass windows and intricately carved oak panelling enhance the serene surroundings of the house to create the perfect getaway.

RATES AND POLICIES TO NOTE:

Our rates range from \$219 to \$485.
Gracious Southern style breakfast and
afternoon tea included. Reservations recommended
with one night's tariff as deposit. Two night minimum
on weekends. No credit cards please.

Two Meeting Street Inn

On the Battery

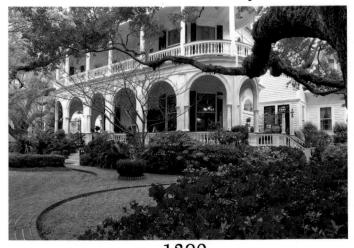

c.1890

Charleston's Oldest and Most Renowned Inn

This beautiful Queen Anne Victorian mansion built in 1890 has welcomed guests for more than 70 years. Beautiful arched piazzas with rocking chairs provide complete relaxation and a panoramic view of the Historic Battery and waterfront.

Filled with family antiques and heirloom accessories, Two Meeting Street Inn offers the finest in Charleston Traditions.

TWO MEETING STREET INN

2 Meeting Street Charleston, SC 29401 (843)723-7322 1-888-723-7322 www.twomeetingstreet.com

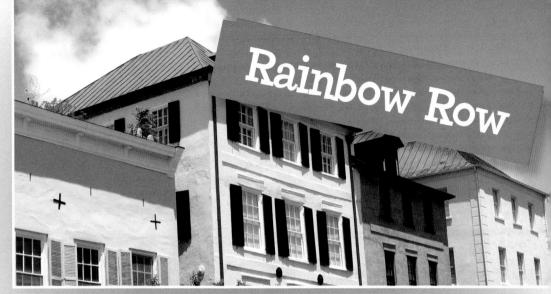

A Colonful Name

Can you guess why this section of East Bay Street is called Rainbow Row?

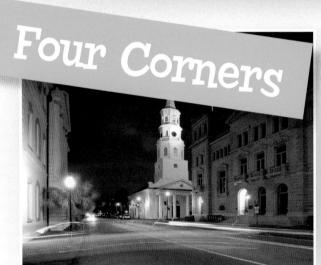

A Lot of Laws

There is an interesting name for the place where Broad and Meeting Streets come together. The area is called the **Four Corners of Law**. Current and former buildings at this intersection represent Federal, State, City, and even God's Law (with St. Michael's Church).

The Holy City

Many Names

Back in the late 1600s and early 1700s, Charleston was called **Charles Town**. But from 1783 until now the city's official name has been Charleston. Its nickname is **The Holy City** because it has so many churches!

Charleston: ANATIC

A HUGE Storm!

At midnight on September 21, 1989, Hurricane Hugo swept through the city. Powerful winds knocked down buildings and snapped off trees. Just north of Charleston, a 20-foot wall of water surged onto land. It was a frightening night for everyone in the city. But the people of Charleston worked together and recovered. The city is now more prepared than ever for any future hurricane that takes aim at it.

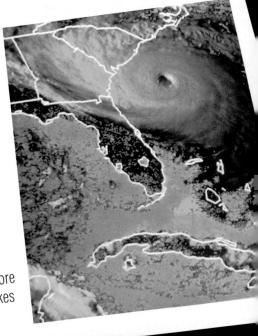

A BIG Blast!

On October 11, 2005, a big blast shook the On October 11, 2005, a big blast shook the old city! That was the day a large part of the old city! That was the day a large part of the old bridge Silas Pearman Bridge was blown up. But don't silas Pearman Bridge was blown up. But don't was done on purpose! The old bridge worry—it was done on purpose! The old bridge worry—it was destroyed because the much larger Arthur was destroyed because the much larger for business. Ravenel Jr. Bridge was now open for business.

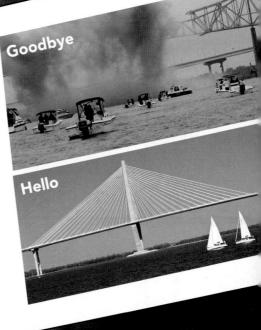

A STRONG Quake!

More than one hundred years ago, on August 31, 1886, a powerful earthquake shook the city. Many buildings were damaged or destroyed. Thousands of people were left homeless.

After the earthquake, it became even more common for people to strengthen buildings by running long iron rods between some of the walls. The gib plates (pieces that hold the rod in place on the outside of the building) are known as "earthquake bolts" and can still be seen on some Charleston buildings today.

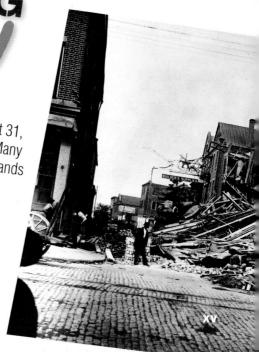

Whats So DA About This

There is a lot to see and celebrate...just take a look!

CONTENTS

Land		 									.pages 2-9
History		 									.pages 10-17
People											
And a Lot More Stuff	!.										pages 26-31

What's So Great About This State?

Well, how about... The Land

Lowcountry

The Atlantic Ocean! That's what borders the whole east side of the state of South Carolina. The land closest to the ocean begins the Coastal Plains. The northeastern part of the Coastal Plains includes the Pee Dee region which is named after a Native American tribe. The southeastern part of the Coastal Plains is called the Lowcountry because...well, it's really LOW! The land in the Lowcountry isn't much higher than the level of the water in the Atlantic Ocean.

The Coastal Plains cover about two-thirds of the state. Sandy beaches and marshes near the ocean soon give way to pine trees and rolling hills. Rivers snake up through the middle of the state (known as the Midlands, of course!) as the land slowly starts to rise. But paddling in a canoe to the northwestern part of the state will get you only so far...

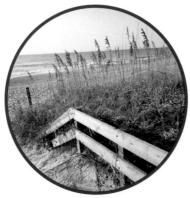

Sand dunes make a natural barrier between water and land.

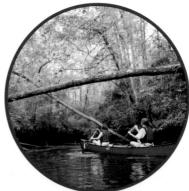

Travelers paddle through a river in the Coastal Plains.

...Why? It's because the upper part of South Carolina is quite a different area! The Piedmont area rises up to meet the base of the Blue Ridge Mountains. Waterfalls, forests, and lakes dot the Upcountry. Fast-moving water travels from the high mountains down through the Piedmont area. A special area—the Fall line—forms where the Upcountry rivers "fall" into the Coastal Plains. And what's at the Fall line? You guessed it—more waterfalls!

It's quite an adventure to explore the land across South Carolina. Take a closer look at the next few pages to see just some of the interesting places you can visit!

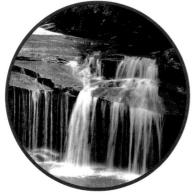

Table Rock State Park waterfall

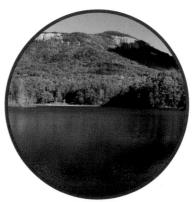

Table Rock Mountain in the Upcountry of South Carolina

A view from Jumping Off Rock at Lake Jocassee

Gorges are found only in the Upcountry part of the state—and in South Carolina, the gorges are known as the Jocassee Gorges. These gorges cross the border of South Carolina and extend northward into North Carolina.

Why are the Jocassee Gorges special? (...and what exactly is a gorge, anyway?)

Glad you asked! A gorge is like a canyon...only smaller! It is a deep and narrow valley with steep rocky sides...and it often has a river or a stream flowing through it.

Over a long, long period of time, mountain streams and rivers flowing down from the Blue Ridge Mountains carved a path through the rocky cliffs of this area. The Jocassee Gorges formed and this area is now protected—which means these wonderful natural resources should be around for quite a while.

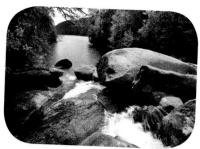

The Lower Whitewater Falls

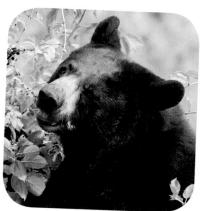

Black bears roam in Jocassee Gorges

What kind of things can I see at the Jocassee Gorges?

You can see rushing waterfalls, fast-moving rivers, and beautiful Lake Jocassee. The Gorges are also home to many different creatures, including wild turkeys, brook trout, and lots of white-tailed deer.

Don't forget the black bears!

Even though you probably won't see any (because these bears generally stay away from humans!) the Jocassee Gorges area does have one of the largest black bear populations in the Southeast. Why do bears hang out there? One reason is that this forest area is rich in berries and nuts—which black bears love to eat!

Beaches and Barrier ISSIANCIS

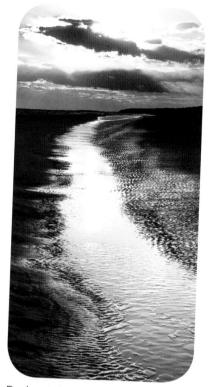

Dusk at Hilton Head beach

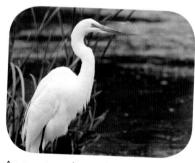

An egret wading at Huntington Beach State Park

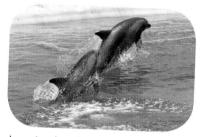

Jumping bottlenose dolphins

Since the Atlantic Ocean borders South Carolina, the whole east coast of the state is loaded with beaches!

Why are the beaches and barrier islands so special?

If you've ever caught a wave in the water or found a shell in the sand you already know why beaches are special. And barrier islands? Well, their name says it all!

Barrier islands protect the mainland coast by providing a block, or "barrier", against wind and ocean waves. The beaches and barrier islands also protect the salt marsh nurseries along the coast. Why is this important? The nurseries are where countless young sea creatures are born or hatched every year!

What can I see at beaches and barrier islands?

Water, sand, beaches, and shells for sure! And of course, the birds! Brown pelicans dive into the water. Seagulls screech in the sky above. Stately herons and egrets stand tall in the marshes.

If you're lucky, you might spot some dolphins!

These graceful creatures often jump above the waves. Sometimes they are feeding on shrimp. Other times, they seem to be just playing on the waves!

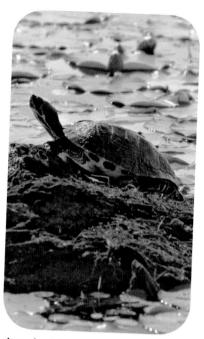

A turtle at home on the lake.

Natural and man-made lakes can be found throughout the state. And since water flows downhill, there are plenty of rivers moving from higher to lower ground in South Carolina.

Why are the lakes and rivers so special?

Lakes and rivers provide recreation, transportation, food, and habitats! Interestingly enough, several large lakes in the state weren't formed by nature but are man-made. Dams built on major South Carolina rivers in the 1930s and 1940s backed up river water. This flooded the land that now lies under Lake Marion, Lake Moultrie, and Lake Murray.

What can I see at the lakes and rivers?

Bullhead, bass, and bream! Is it the name of a new restaurant? Nope...these are the names of some of the different kinds of fish swimming in South Carolina lakes and rivers.

What's a blackwater river and why is the water so dark?

Fast-moving whitewater rivers flow from the Uplands down through the Piedmont. But blackwater rivers move more slowly through spooky-looking swamps and soggy wetlands of the Coastal Plains. The Edisto River is the longest free-flowing blackwater river in the United States! It twists and turns more than two hundred miles through the state.

Tons of leaves and other plant parts fall into the rivers to rot. Stuff (called tannins) from the decaying plant material turns the river water dark in color.

The Edisto River is a long blackwater river!

What's So Great About This State?

Well, how about...

Tell Me a Story!

The story of South Carolina began thousands of years ago. At this time, many Native Americans made their homes throughout the state. Most lived in groups called tribes and descendants from many tribes still live in the state today.

You often hear people speak of these Native American tribes because many places throughout the state are named in their honor. The Edisto River, the Pee Dee River, Oconee State Park, Santee State Park—these names all honor the groups of people who first lived on this southeastern land so long ago.

This statue honors the Cassique, or Chief, of the Kiawah tribe who welcomed the first permanent English settlers to the historic site now called Charles Towne Landing.

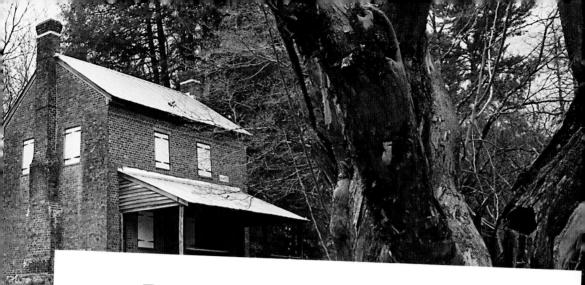

...The Story Continues

Eventually, South Carolina became home to many other groups, including Spanish explorers, European American settlers, and African Americans. Many battles for independence were fought in South Carolina—but history isn't always about war. South Carolinians have always educated, invented, painted, written, sung, and built. Many footprints are stamped into the soul of South Carolina's history. You can see evidence of this all over the state!

South Carolina is an original! As one of the original 13 colonies, the state had a strong presence in the Revolutionary War.

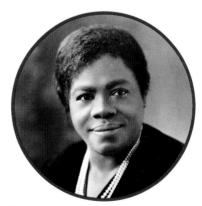

Mary McLeod Bethune was an educator and civil rights leader who was born in Mayesville, SC.

MONUMENTS

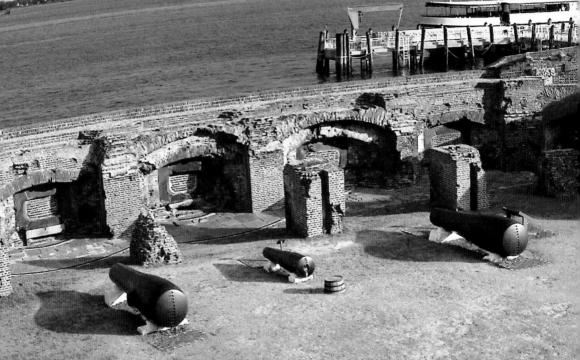

Monuments honor special people or events. Fort Sumter is a national monument located at the entrance of the harbor of Charleston, South Carolina. The fort is named for a South Carolina Revolutionary War hero, but it is known as the place where the first shots of the Civil War were fired.

Why are South Carolina monuments so special?

That's an easy one! The hundreds of monuments (and memorials) throughout the state honor soldiers, poets, politicians, and "extraordinary" ordinary people who helped shaped both the state of South Carolina and the nation.

What kind of monuments can I see in South Carolina?

There are statues, plaques, markers, cornerstones, bridges, named streets—almost every town has found some way to honor a historic person or event.

Where are monuments placed?

Anyplace where something important happened!
For example, during the Revolutionary War, a cow pasture in Cowpens, South Carolina was turned into a battlefield. Today that pasture is preserved as a national historic site known as the Cowpens National Battlefield.

The picture shows a monument that honors the Tuskeegee airmen. These African American pilots were respectfully nicknamed the "Red Tail Angels" for their bravery in flight.

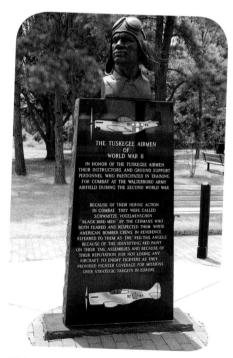

This marker honors the Tuskeegee Airmen and those who helped train them for combat at the Walterboro, SC Army Airfield during World War II.

Museums

The EdVenture Children's Museum in Columbia, SC

Museums don't just tell you about history—they actually show you artifacts from times past. Artifacts can be actual objects or models of objects—either way, they make history come alive!

Why are South Carolina's museums so special?

South Carolina's museums contain amazing exhibits with artifacts that tell the story of the state. In fact, the State Museum in Columbia is actually an artifact itself! The museum is housed in what was once the world's first all-electric textile mill.

Some museums even float!

At the Patriots Point Naval and Maritime Museum you can actually climb onto the USS Yorktown (CV-10) aircraft carrier. This huge ship is the length of three football fields and was once home to 3,000 sailors!

What can I see in a museum?

An easier question to answer might be "What can't I see in a museum?" There are thousands of items exhibited in all kinds of different museums across the state. Do you want to know about the state's insects? The Clemson University Arthropod Collection has over one hundred thousand invertebrates on display! Or perhaps you are interested in stock car racing? Then the Joe Weatherly Museum in Darlington, South Carolina is the place to visit!

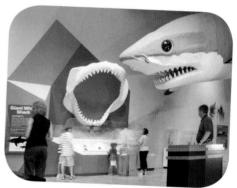

The Giant White Shark exhibit at the South Carolina State Museum

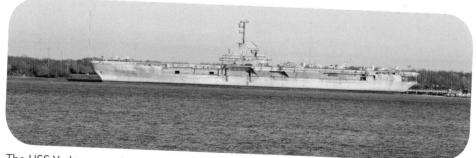

The USS Yorktown at the Patriots Point Naval Museum in Mt. Pleasant, South Carolina once played a big role in World War II

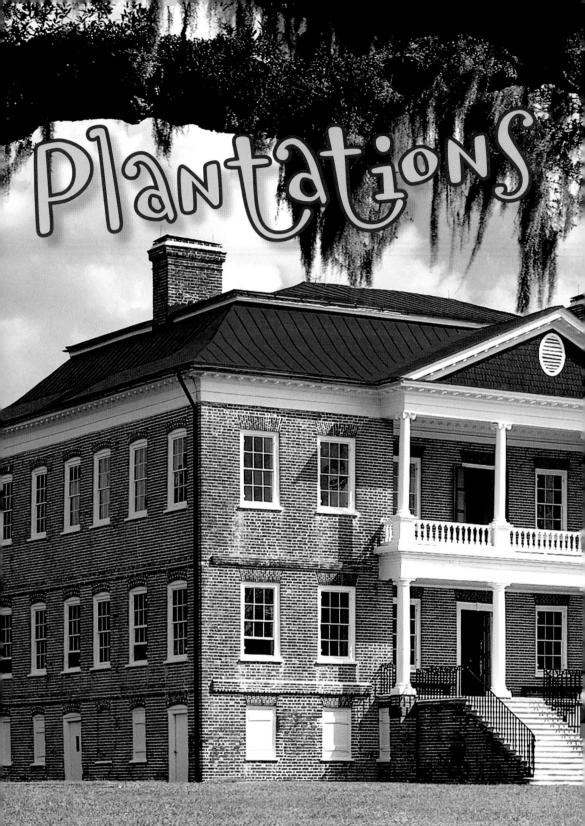

The Drayton Hall Plantation was built around 1738.

The Drayton Hall Plantation is preserved in its nearly original condition. What does that mean? It means that it has no electricity, no plumbing, no heating, and no air conditioning!

Why are plantations special? (....and what is a plantation, anyway?)

Plantations were large estates or farms where crops such as rice and cotton were grown. Enslaved Africans, and, later, enslaved African Americans, did most of the work on a plantation.

Today, many plantations tell the shared history of our country. All have fascinating stories of race, culture, families, and sacrifice.

What can I see if I visit a plantation?

Some plantations show you what life was like hundreds of years ago. You can still see the work of many enslaved people who became skilled blacksmiths and coopers. (A cooper is someone who makes all the different containers, such as barrels and buckets, used on a plantation.)

...and there's more!

Other plantations today grow beautiful gardens and produce real food crops. The Silver Bluff Plantation in Aiken, SC is now owned by the Audubon Society. This plantation is a wildlife sanctuary...it provides a protected home for many birds such as bald eagles, wood storks, and redheaded woodpeckers.

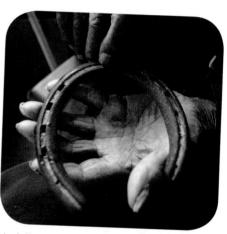

A skilled blacksmith shows a horseshoe.

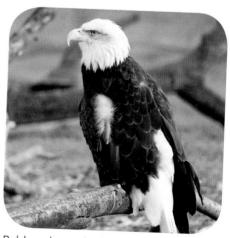

Bald eagles and other wildlife are protected at The Silver Bluff Plantation in Aiken.

What's So Great About This State?

Well, how about... The People!

Enjoying the Outdoors

More than four million people live in the state of South Carolina. Though they have different beliefs and different traditions, South Carolinians have plenty in common.

Most share a love of nature. Because South Carolina has such a mild climate, people are able to enjoy the outdoors all year long. Surfing, golfing, hiking, boating, fishing, swimming—the list of things that South Carolinians enjoy goes on and on! Since the natural environment is so important to South Carolinians, most feel a shared responsibility to take care of it.

Casting a net in a tidal creek might bring in blue crab or shrimp.

Sesquicentennial Park in Columbia is a good place to picnic with friends.

Sharing Traditions

The people of South Carolina share the freedom to celebrate different heritages. Enslaved people brought to South Carolina from West Africa and the West Indies were not allowed to speak their own languages. So they developed a new one—called Gullah—which is a combination of English and African words. The Gullah culture is still alive today and preserves many rich traditions.

Did you ever wonder what a Civil War battle was like? South Carolinians often re-create battles to honor the history and heritage of brave soldiers. Cooking is another way to pass on traditions. Great Southern food recipes are cherished family keepsakes!

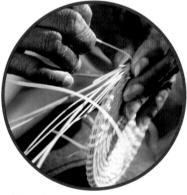

Weaving sweetgrass baskets is one Gullah tradition that has become a well-respected art.

A ball game at Andrew Jackson State Park offers the chance to celebrate both the old and the new.

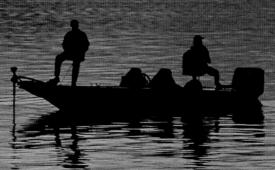

Fishing at Hickory Knob State Resort Park

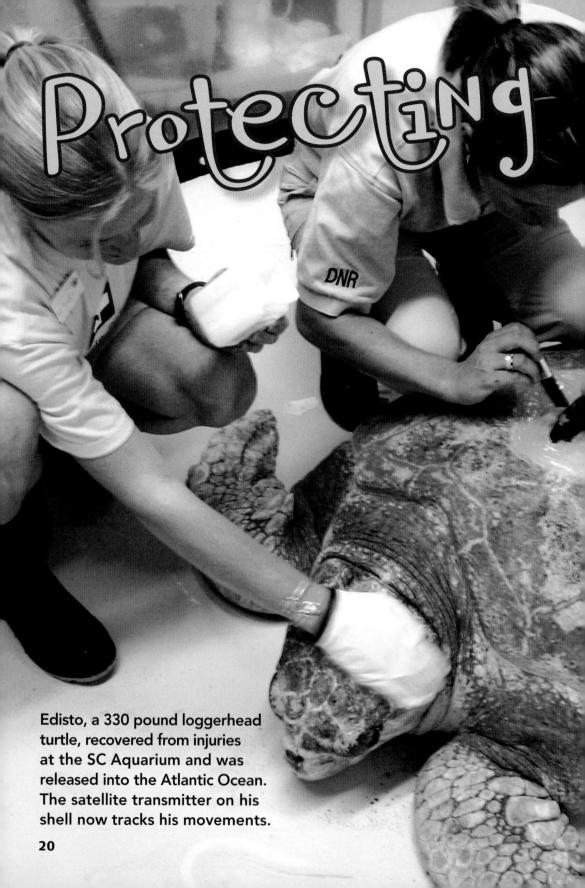

Protecting all of South Carolina's natural resources is a full time job for many people!

Why is it important to protect South Carolina's natural resources?

The state of South Carolina is only about two hundred miles wide, but you'll find a lot of different environments within its borders. Going inland from the coast, the land changes from coastal marshes and blackwater rivers to mountain forests and whitewater falls. All these different environments mean many different kinds of plants and animals can live throughout the state. In technical terms, South Carolina has great biodiversity! This biodiversity is important to protect because it keeps the environments balanced and healthy.

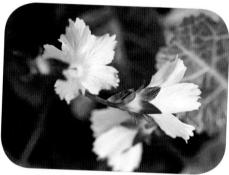

The Oconee Bell is a rare flower in the wild. But it is one of the first spring blooms in Devils Fork State Park.

A state park ranger talks to kids about a forest habitat.

What kinds of organizations protect these resources?

It takes a lot of groups to cover it all. The U.S. Fish and Wildlife Service is a national organization. The SC Department of Natural Resources and the SC State Parks Service are state organizations. Of course, many smaller groups exist as well. The Center for Birds of Prey in Awendaw, South Carolina treats nearly four hundred injured birds each year!

And don't forget...

You can make a difference, too! It's called "environmental stewardship" and it means that you are willing to take personal responsibility to help protect South Carolina's natural resources. It's a smart choice for a great future!

Goats await milking at Split Creek Farm in Anderson, SC. 22

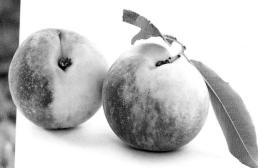

Although Georgia is known as the Peach State, South Carolina grows more peaches.

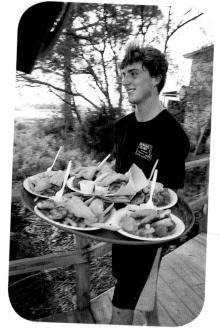

Service work is plentiful in the state.

Military training is hard work!

Some jobs, such as growing cotton, have been around since the state was first formed. Other jobs, such as film-making, are new and growing in demand.

Why is South Carolina a good place for business?

The land and the people make a good combination for a variety of businesses throughout the state.

What kinds of jobs are available throughout the state?

South Carolinians have always been good at making things. Today, many people work in the manufacturing industry. From fabric and cars to chemicals and paper, great products come through warehouses all over the state.

Farming has always been important to the state. Another big industry is the service industry. It's growing in large part because millions of tourists travel through the Palmetto State each year. Many jobs are needed to help people sightsee, dine, and relax!

Don't forget the military!

The Air Force, Army, Marines, Navy and the Coast Guard all have a presence in the state. Whether training or working, the brave men and women who serve our country are held in great respect throughout South Carolina.

Celeprating

South Carolina State Fair in Columbia

The people of South Carolina really know how to have fun! The State Fair draws tens of thousands of people to the capital city of Columbia each year.

Why are South Carolina festivals and celebrations special?

Celebrations and festivals bring people together. From cooking contests to surfboarding, events in every corner of the state showcase all different kinds of people and talents.

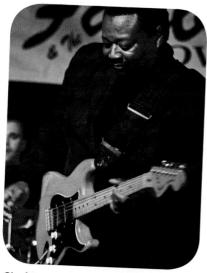

Chef Barry "Fatback" Walker cooks at a great restaurant in Columbia. He also plays jazz music on his guitar!

The Atalaya Festival at Huntington Beach State Park showcases amazing artwork in a beautiful outdoor location.

What kind of celebrations and festivals are held in South Carolina?

Too many to count! But one thing is for sure, you can find a celebration or festival for just about anything you want to do. Do you like to eat peaches? Gaffney has held a Peach Festival every year for more than thirty years.

Do you like to watch car races? Stock cars speed around the Darlington racetrack at more than 180 miles per hour. Want to hear some great music? Try the Main Street Latin Festival in Columbia or the Spoleto Festival in Charleston!

Don't forget about the Governor's Frog Jump Contest!

Yes, it's true! For more than forty years there has been a frog jumping contest in Springfield, South Carolina. The winner gets to go to the Calaveras County Frog Jump in California which honors a story written by Mark Twain in the 1800s.

and

What do all the people of South Carolina have in common? These symbols that represent the state's shared history and natural resources.

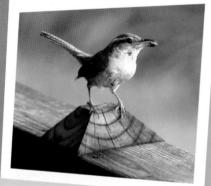

State Flower Yellow jessamine

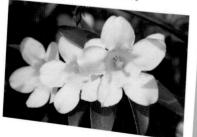

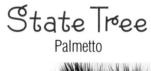

Can a tree be a state hero? You bet! The palmetto tree helped South Carolinians defeat the British in 1776 during the Revolutionary War. Fort Moultrie was built of sand and palmetto wood. When the British took aim at the fort, the spongy walls absorbed most of the enemy fire!

State Fruit

Peach

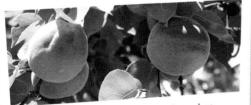

There are more than 30 varieties of peaches in South Carolina. How many have you tried?

State Reptile Loggerhead sea furtle

State Animal White-tailed deer

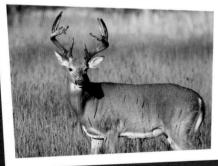

State Flag Adopted in 1861

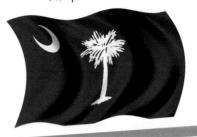

State Gem

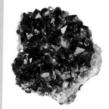

One of the most beautiful pieces of amethyst comes from South Carolina! It's on display at the American Museum of Natural History in New York City.

State Butterfly Eastern tiger swallowfail

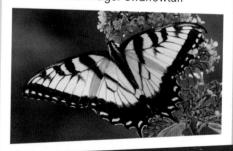

Want More?

Statehood—May 23, 1788 State Capital—Columbia State Nickname—Palmetto State State Song—"Carolina" State Insect—Carolina mantid State Game Bird—Wild turkey State Spider—Carolina wolf State Shell—Lettered olive State Stone—Blue granite State Beverage—Milk State Dance—The shag

More Facts

More

Here's some more interesting stuff about South Carolina!

The Dotted Line

At 26, Edward Rutledge of Charleston was the youngest signer of the Declaration of Independence.

Fit For a King

The state of South Carolina was named after King Charles I of Great Britain.

Battlefield

More than 125 Revolutionary War battles were fought on South Carolina soil.

Rooted in History

The "Avenue of Oaks" at Boone Hall Plantation in Mt. Pleasant, SC was started in 1843. More than 160 years later, the 88 oak trees, draped in Spanish moss, form a spectacular sight that stretches for three-quarters of a mile.

The Great Outdoors

South Carolina has 4 state forests and 47 state parks.

Nice Digs!

The beautiful Edisto Memorial Gardens has earned Orangeburg the title of the "Garden City".

Lights, Camera, Action

Some movies made in South Carolina include Forrest Gump, Ace Ventura, Cold Mountain, Die Hard with a Vengeance, and That Darn Cat.

Gritty

A landmark since the early 1800s, the restored Golden Creek Mill near Easley still uses a water wheel to power the old milling equipment inside.

Fore!

Myrtle Beach is the "Miniature Golf Capital of the World." There are about 50 courses, including ones with dinosaurs, pirates, airplanes, dragons, and fire-spewing volcanoes.

Original Recipe

Frogmore stew originated near Beaufort. This one pot meal usually contains seasoned sausage, shrimp, corn, and potatoes.

Big Blocker

The Dreher Shoals Dam (that formed Lake Murray) is still one of the largest earthen dams in the United States.

Tick Tock

Built back in the 1830s, the town clock in Winnsboro is thought to be the longest continuously running town clock in the nation.

Gotcha Covered

Campbell's Covered Bridge, near Gowensville, is the only remaining covered bridge in the state.

What a Peach

It took 50 gallons of paint to turn a milliongallon water tower in Gaffney into a giant peach with a 12-foot stem and a 60-foot leaf.

Small to LargeThere are 46 counties in South Carolina. The smallest county in South Carolina is McCormick and the largest county is Horry.

What a View!

From Sassafras Mountain, the state's highest point, you can see Tennessee, North Carolina, and Georgia.

A Walk in the Park

Cheraw State Park in Chesterfield County was founded in 1934 and is South Carolina's oldest state park.

Do You Have the Time?

Barnwell's 150-year-old vertical sundial is the only one of its type in the country. It stays within minutes of standard time.

A Celebrated Fruit

The Hampton County Watermelon Festival is the oldest continuously held festival in the state. It began in 1939.

Plowed Over

The Darlington Raceway was once an old cotton and peanut field.

Find Out More

There are many great websites that can give you and your parents more information about all the great things that are going on in the state of South Carolina!

State websites
The Official Web Site of the
State of South Carolina
www.sc.gov

South Carolina State Parks www.southcarolinaparks.com

The Official Tourism Site of South Carolina www.discoversouthcarolina.com

Museums/Columbia
South Carolina State Museum
www.museum.state.sc.us

Columbia Museum of Art www.columbiamuseum.org

Charleston
The Charleston Museum
www.charlestonmuseum.org

Children's Museum of the Lowcountry www.explorecml.org

Darlington
Joe Weatherly Museum, NMPA Stock
Car Hall of Fame
www.autospeak.com/museum03.htm

Gaffney
Cherokee Historical & Preservation
Society, Inc.
www.cherokeecountyhistory.org

Greenville
Upcountry History Museum
www.upcountryhistory.org

Hilton Head Coastal Discovery Museum www.coastaldiscovery.org

Myrtle Beach South Carolina Hall of Fame www.theofficialschalloffame.com

Children's Museum of South Carolina www.cmsckids.org

Aquariums and the Zoo South Carolina Aquarium (Charleston) www.scaquarium.org

Riverbanks Zoo (Columbia) www.riverbanks.org

Ripley's Aquarium (Myrtle Beach) www.ripleysaquarium.com

South Carolina: At A Glance

State Capital: Columbia

South Carolina Borders: Atlantic Ocean, Georgia, North Carolina

Population: Over 4 million

Highest Point: Sassafras Mountain is 3,560 feet (1085 meters) above sea level

Lowest Point: Sea level on the coastline

Major Cities: Columbia, Charleston, North Charleston, Greenville, Rock Hill

Some Famous South Carolinians

John C. Calhoun (1782–1850) from around Abbeville, SC; was an American senator and political philosopher.

Mary McLeod Bethune (1875-1955) from Mayesville, SC; was an educator and president of a college for young African American women.

Mary Boykin Miller Chestnut (1823-1886) from Statesboro, SC; was a writer who recorded her Confederate experiences in a series of famous diaries.

May Craig (1889-1975) from Coosaw, SC; was a female journalist who reported from the front lines of battle during World War II.

Althea Gibson (1937-2003) from Silver, SC; was the first African American woman to win both Wimbledon and the U.S. National Championship in tennis.

Dizzy Gillespie (1917-1993) from Cheraw, SC; was a famous jazz trumpet player, bandleader, and composer.

Andrew Jackson (1767-1845) from Waxhaw, SC; became the seventh president of the United States.

Francis Marion (1732-1795) from Berkeley County, SC; was called the Swamp Fox as a commander in the American Revolutionary War.

Ronald McNair (1950-1986) from Lake City, SC; was an astronaut for NASA who received the Congressional Space Medal of Honor.

Charles Hard Townes (born 1915) from Greenville, SC; is a scientist who won the 1964 Nobel prize in physics.

Darius Rucker (born 1966) from Charleston, SC; is the grammy-winning lead singer and guitarist for the band Hootie and the Blowfish.

Fishing at Hickory Knob State Resort Park

CREDITS

Series Concept and Development

Kate Boehm Jerome

Series Design

Steve Curtis Design, Inc. (www.SCDchicago.com)

Reviewers and Contributors

Stacey L. Klaman, writer and editor, San Diego, CA
Marc Rapport, Manager Media Relations, SC Department of Parks, Recreation & Tourism

Photography

Back Cover(a,b), Back Cover(d,e), Cover(e), 2-3, 2(a), 2(b), 3(a), 3(b), 4-5, 5(a), 7(b), 8-9, 9(a), 9(b), 10-11, 10, 12-13, 14-15, 17(a), 18-19, 18(a,b), 19(a,b), 21(a,b), 22-23, 23(a), 24-25, 25(a,b), 26(c), 32 @ Perry Baker/SCPRT; Back Cover(c), 26(b) @ Cathy Luckhart/Shutterstock; Cover(a) @ Lawrence Cruciana/Shutterstock; Cover(b), 6-7 @ Jason Tench/Shutterstock; Cover(d), 7(a) @ July Flower/Shutterstock; Cover(f) @ iofoto/Shutterstock; Cover(g) @ Steven Faucette; 5(b) @ nialat/Shutterstock; 7(c) @ Henry William Fu/Shutterstock; 11(a) @ n4 PhotoVideo/Shutterstock; 11(b) @ Scurlock, Archives Center, National Museum of American History, Smithsonian Institution; 13 @ Michael Stroud; 15(a) @ Susan Dugan/South Carolina State Museum; 15(b) @ Condor 36/Shutterstock; 16-17 @ Ron Blunt/Drayton Hall; 17(b) @ Alexey Stiop/Shutterstock; 20-21 @ South Carolina Aquarium; 23(a) @ Apollofoto/Shutterstock; 23(c) @ John Wollwerth/Shutterstock; 26(a) @ Benjamin F. Haith/Shutterstock, 27(a) @ Larry Ye/Shutterstock; 27(b) @ Carsten Reisinger/Shutterstock; 27(d) @ Marco Cavina/Shutterstock; 27(e) @ Bruce MacQueen/Shutterstock; 27(f) @ Craig Hosterman/Shutterstock; 28 @ Terence Mendoza/Shutterstock; 29(a) @ Dewitt/Shutterstock; 29(b) @ Hannamariah/Barbara Helgason/Shutterstock; 31 @ R. Gino Santa Maria/Shutterstock

Illustration

Back Cover, 1, 4 @ Jennifer Thermes/Photodisc/Getty Images

Copyright © 2008 Kate Boehm Jerome. All rights reserved. No part of this book may be used or reproduced in any manner without written permission except in the case of brief quotations embodied in critical articles and reviews.

ISBN 978-1-4396-0000-9

Library of Congress Catalog Card Number: 2008937172

Published by Arcadia Publishing

Charleston SC, Chicago IL, Portsmouth NH, San Francisco CA

For all general information contact Arcadia Publishing at:

Telephone 843-853-2070

Fax 843-853-0044

Email sales@arcadiapublishing.com

For Customer Service and Orders:

Toll Free 1-888-313-2665

Visit us on the Internet at www.arcadiapublishing.com